2008

Because I love you.
Happy Valentine's Day, Patrick.

I'm yours,

Karen

 SAM SCOTT

Encounters With Beauty_____

EXCERPTS FROM AN
ARTIST'S JOURNAL
1963 - 2006

FRESCO FINE ART PUBLICATIONS, LLC ALBUQUERQUE, NM

For Leslie

SAM SCOTT
Encounters With Beauty

Editor
William Peterson

Introduction
©2007 William Peterson

Publisher
Fresco Fine Art Publications, llc
Albuquerque, New Mexico
www.frescobooks.com

Color
Mankus Studios, Santa Fe

Printed in Italy
ISBN 0-9679034-4-0
Library of Congress Catalog Card Number: 2007923233

SAM SCOTT

ENCOUNTERS WITH BEAUTY

FRESCO FINE ART PUBLICATIONS, LLC

Albuquerque, New Mexico

I know what the great cure is: it is to give up,
to relinquish, to surrender, so that our little hearts
may beat in unison with the great heart of the world.

—Henry Miller

TABLE OF CONTENTS

Introduction

SAM SCOTT: AN ARTIST'S JOURNAL

The writings of artists hold a special fascination. We know that writing is not their first choice as a means of expression, and that the visual concerns that consume their lives are not easily put into words. Since the creative process generally requires both intense concentration and a kind of vulnerable receptivity, the making of art has always been a private matter and most artists are inclined to be secretive about it. Still, we are interested in their thoughts and curious about the particular universe that they bring to the making of their work.

When Christian Zervos wanted to show Picasso the notes he had made of their conversation before publishing them in 1935, Picasso replied, "You don't need to show them to me. The essential thing in our period of weak morale is to create enthusiasm. . . . Enthusiasm is what we need, we and the younger generation."

Enthusiasm, and the encouragement of enthusiasm, as much as anything, is the motivating force behind Sam Scott's interest in publishing his journal notes. The word "enthusiasm" originally meant to be inspired or possessed by a god (en-theos). For an artist like Sam, living on inspiration and vitally concerned with the spiritual resonance of art, enthusiasm leads to

exuberance, a rich and abundant outpouring. As William Blake said, "Exuberance is Beauty."

In his "Encounters with Beauty" Sam Scott has made a small collection of his writing. With the exception of the speech delivered at the United Nations, which might be called an "occasional" piece, prompted by a specific occasion, these are mainly short excerpts from the artist's journal. Some were jotted down on the fly as the inspiration came. Others, such as the Pollock and Van Gogh pieces, were more labored as he developed the ideas. Because they are journal excerpts, the writing can be somewhat patchy, but the texts are laced with poetic observations and conjunctions throughout. They are written from the heart as the artist converses with himself, attempting to give some tentative order and organization to his thoughts. Of course, he also brings to this internal conversation his encounters with ideas gathered from his many surrounding interests, including his readings and conversations with others.

Incorporating many sources of experience, then, these journal entries are rhapsodic improvisations. In several of them I could hear the voice of the great mid-twentieth-century thinker Hannah Arendt, and discovered her words sometimes spilling like keys and coins from his pockets as he wrestled with his own personal angel. He is not writing academic scholarship, however, and there's no need for footnotes. The ideas of others always become part of us and serve as helpers, directing and aiding in the formulation of a thought.

They are simply some of the many voices that inhabit us.

While a high moral concern and a rich range of ideas suffuse Sam's meditations, they can't truly be called theoretical, since they are not finally systematic. Nor is there any dogged orthodoxy. As he wrestles with his angel Sam is not even too bothered by contradiction, like the Yogi Berra remark that he quotes, "When you come to a fork in the road, take it!"—Exactly: just what you'll need if you're going to have your cake and eat it too! Arendt liked to call her essays "exercises in thought," and Sam's entries are similarly exercises, flexing the mind and imagination for their own sake and dancing with the muse, rather than marching toward some dogmatically purposeful end. The point is to stay limber. "Exuberance is Beauty."

"Art is not an imitation of nature but its metaphysical supplement, raised up beside it in order to overcome it." Quoting this famous statement from Nietzsche's *The Birth of Tragedy* in her essay, "On Style," Susan Sontag quickly adds her own reminder that, "The overcoming or transcending of the world in art is also a way of encountering the world, and of training or educating the will to be in the world." This interchange of the physical and metaphysical is clearly central to Sam Scott's thinking about art, and his deep commitment to art's spiritual and moral dimensions has evolved in concert with an abiding personal reverence for the natural world.

Seeing the paintings of Vincent van Gogh at the Art Institute of Chicago at the age of twelve, Sam realized that he wanted to be an artist. Since then he has constantly nourished and expanded his innate artistic inclinations with a profound appreciation for artistic expression throughout the ages and an ecumenical interest in world traditions of the sacred. His involvement with the latter has extended from his early schooling in philosophy and his youthful ambition to train for the Episcopalian ministry, to his encounters with shamanism among the Ogalala Sioux of South Dakota and the Makiritari tribes of the Amazon. A seminar with Gregory Bateson in the 1960s introduced him to the subtle interconnectedness of natural systems, while a long-standing admiration for the compassionate humility in the life of Saint Francis would help him to balance all the existential doubts that arose as he read Sartre and Camus and came to terms with their imperative of taking moral responsibility for one's own life. His later affection for the teachings of Zen Buddhism connected him with the twin roots of its wisdom in the ancient Tao and Hinduism, as much as it also introduced him to the art of the Japanese brush masters and the ritual of the Tibetan sand painters.

He trained as a painter at the Maryland Art Institute in the late 1960s under Grace Hartigan, and had graduate painting classes with Clyfford Still and Philip Guston. He traveled widely, working in Italy and

Mallorca, Mexico, Tahiti, and Alaska, before settling in Santa Fe in 1969. Except for a period in Tucson teaching at the University of Arizona, Sam has maintained his studio in Santa Fe, where he paints with an intuitive approach that ranges from a lavish lyrical abstraction that is richly brushstroked and sumptuously colored, to mytho-poetic works with a fugitive figuration that draw on the lingering spiritual resonance of the land and ancient peoples of the Southwestern region. In recent years he has continued to travel, doing watercolors in Vietnam and in the south of France, where contact with the works of the early French modernists brought a renewed interest in formalist figure studies and still-life subjects into his repertory.

Certain affinities with Neo-Platonist philosophy are striking in these journal notes, although I know that at the time he made these entries Sam had no direct knowledge of the writings of Plotinus, the third-century Greco-Roman philosopher who refined the mystical tendencies inherent in Plato's original conception that an abstract realm of Ideas (eidos) pre-exists the material world. When the Humanists at the Renaissance court of Lorenzo de' Medici rediscovered Plotinus and married his mystical version of Plato to their own Christian beliefs, they passed this philosophy on to the young Michelangelo. The struggle of the immortal soul imprisoned in worldly matter would become the essential theme of Michelangelo's sculpture. On the ceiling of the

Sistine Chapel he would paint the journey of the soul out of the baseness of ignorance and bondage in physicality (the Drunkenness of Noah), through the awakening of ambition (the Creation and Fall of Adam and Eve) and into the highest celestial realm of pure spirit and intellect, where it culminates in God's ethereal and purely spiritual act of Separating Light from Darkness. That cloudlike activity of pure Spirit in the final panel, directly above the chapel's altar, alludes not only the pure intellectual act of dividing Truth from Falsehood and the Known from the Unknown, but also the separation of Being from Nothingness, hence it is the primal act of Genesis or beginning—the initial separation of the many from the One, from which the Cosmos spilled into existence.

Sam is not alone among artists who have pursued such burly notions of the sublime. They are deeply embedded in our tradition, from Wordsworth's "Intimations of Immortality" to Mondrian's discovery that the dynamic equilibrium between a horizontal and a vertical line can define the balance of the cosmos.

"Why give Him—faith—a name? Like giving a work a title—isn't 'one,' or 'The One,' enough?" Those are the words of Jackson Pollock, as noted down by Jeffery Potter, who had asked him about God. "Way I see it," Pollock continued, "we're part of the one, making it whole. That's enough, being part of something bigger. Let the Salvation Army take over the gods. We're part of the

great all, in our lives and work. Union, that's us." And when asked about creativity, he added, "An artist knows what he's doing, or should. It's not something you talk about, only feel—deep, deep inside. What I do, I unite parts of union into a bigger whole. With enough, that created whole turns into being."

Curiously, such notions are also close to the ancient Chinese *Tao Te Ching* of Lao-tsu, which speaks of a presence in the universe that is all-pervading, self-contained, and is the matrix from which all things are generated. "I do not know its name," says Lao-tsu, "so I call it the Path or Way (*Tao*)." Sam's notes often refer to the Path of the Artist and contact with the ultimately real in the living present.

During the forty-plus years of his life as a painter, while so much of the art world has turned to the cold severities of the conceptual and the analytic, Sam Scott has remained committed to an art that is sensual and synthesizing. Now, as art seems increasingly determined to become what Peter Plagens calls "the putatively transgressive arm of the fashion and entertainment industry," Sam makes his case for the primal place of art. He wants to remind us of the delicate balance that must be maintained in the relationship of art and life.

—William Peterson

Scott.

THE WORK OF ART
AND THE PERMANENCE OF THE WORLD

What is the meaning of our art within the condition of our "modern identity?" How can we address those artistic and ethical dilemmas that together shape our modern notion of what it means to be a human being at the beginning of the twenty-first century? As the painter Robert Motherwell observed, "All we have learned as moderns is that a painting is neither a decoration nor an anecdote." It's a tough job, trying to find a verbal equivalent for what is ultimately inexpressible. After all, how can one explain to others the painter's all-consuming love of the virtual, which urges us on, again and again, to create

that one authentic sign that can at once be, and not be. Abiding with this experience, I know that when I paint, I am speaking the language of an infinite plasticity, one that holds the promise of extension into those spaces and silences that cannot be contained by any verbal syntax.

While I cannot speak for all artists, as a painter I know that art is not *about* experience; rather it *is* a lived experience. Within the sanctuary of the studio the artist withdraws from the flow of daily life, but not from responsiveness to the world. Studio activity is nothing less than a living and concrete evidence of the artist ceding his or her will to be ravished. Such openness and such hunger for the ultimately real is concentrated in the artist's encounter with the canvas and in a heightened attentiveness to the deeply rooted experience of the present moment, the now. It is that arrested present which ultimately defines the work of art, because it is the very sacred essence of what it means to begin, to create. It is what suffuses the work with vibrant value, because it is within the condition of an arrested present that the work of art becomes a cipher of the visible, offering a glimpse of the permanence of the world.

The artist's encounter with the ultimately real results in a work of art—a non-use object that holds vibrant value. A chair is a use object; it is meant to be incorporated into the daily metabolism of the life process, and its form is determined and defined by its utility and function. It is destined to be worn out and even eventu-

ally "used up" by that very process and by its reabsorption into the flow of time. A work of art, however, is not intended for any such use. It is perfectly useless; non-utilitarian. The deep meaning that abides within its condition as an arrested present not only releases the work of art from the exhaustibility of function, but it also causes it to become transmortal. Art is transmortal in the sense that it is meant to stay in the world, to outlast the coming and going of mortal generations. It is also transmortal because it is meant to hold within its form unchanging aspects of Selfhood, Meaning, and the Good. These are the great vibrant values that assuage us as mortal humans in our collective helplessness before the inexplicable. A great work of art grafts us to the universal by that which is most our own.

In its pure visibility art is a cipher of the permanence of the world. Every great work of art, in all its naturalness, exactness, suchness, and inevitable completeness, exists in a Moral Space as well as an Aesthetic Space. How are we grafted to the universal by that which is most our own? By first knowing where we are. To know where we are, we must know where we stand. Knowing where we stand is a description of Moral Space. It is imperative that we maintain at all costs a condition of congruity between our actions and our convictions. First we must know what we are about and then we must live by it. Modern identity has tended to focus on what it is right to do, rather than on what it is good to be. That is to say, we

are more likely to be concerned with defining the contents of obligation rather than with the nature of a good and meaningful life. Art, however, can show us how to be.

We can now entertain an intimacy with spaces which are neither outside nor inside, but rather are endemic to all Being. Those spaces discerned through the poetry, music, and painting of our time are resonant spaces—spaces, which, as Merleau-Ponty says, "are reckoned only as starting from the individual as the zero point, or degree zero, of spatiality." Here, at this point in space, the permanence of the world emblazes on us for one burning moment of present time. Beauty, Wisdom, Selfhood, and the Good—in other words, our Selfhood and our Morality—are immanent in our aesthetic forms and expressions and turn out to be inextricably intertwined themes. Because it is transmortal, the work of art is like an angelic messenger. It brings us awareness of our vital human personhood through the grounding of our experience into the possibility of Grace.

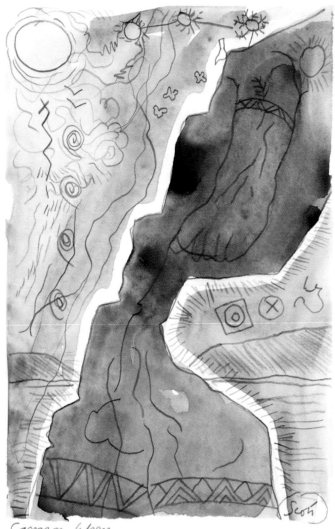

Canyon When

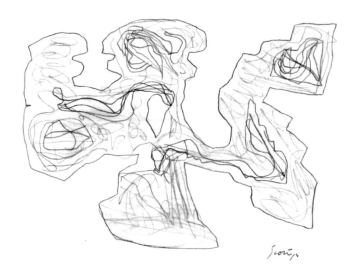

THE CREATIVE ACT: ABOLITION
OF HISTORY AND RECOVERY OF THE
SACRED DIMENSION

"History is a nightmare from which I am trying to awake," said James Joyce's Stephen Dedalus. In creative experience, we are confronted with the abolition of history and the recovery of the sacred dimension. "For all history," as Mircea Eliade wrote in the forward to his book on shamanism, "is in some measure a fall of the sacred, a limitation, and a diminution." In this sense, the life of every culture entails a "history," a departure from the sacred primary experience, a fall which then seems to lead only in the direction of a full-fledged flight into the future.

In our present technological civilization, the possibility of spontaneously living again a fuller revelation of the sacred has been so thoroughly diminished, that it is now viewed as suspect and a possible threat to the whole fabric of society. Why is this so? Perhaps it is because historical consciousness tends to presuppose an ideology of progress, which is always oriented towards a future that is in opposition to an ever-receding and outmoded past. Any effort to transcend this historical ideology, for example, brave art, would therefore be regarded as archaic, or regressive. "Archaic" is generally thought to mean "antiquated" or "outdated" in keeping with the modern historical point of view. But the Greek root of "archaic" is *arche*, which means "the beginning." In a sense, then, what is archaic may not be backward at all, but actually concerned with beginning.

Because the academic view of historical progress is oriented to the future, what takes on the most importance is some utopian end—be it redemption or apocalypse—and not a beginning, certainly not *the beginning*. Thus, as a source of the self, historical consciousness wishes to abolish the archaic experience, that is to say, the art experience, or any *initiating* creative act. Political history does not like to believe in the possibility of a new beginning. From the sacred point of view, however, it is the concept of history and its progress that is outdated, or perhaps we might say, overdated.

The very meaning of the sacred, which high art once

served as a handmaiden, is to bind the many back into one. It means to be in relationship to primary beginning and to the origin of all things. Thus the sacred creative act holds implicit within its identity a reversal of the historical process. An authentic spiritual revival, such as that foreseen by Aldous Huxley, would be a return to the beginning, to the primordial condition of unity. This beginning, this *arche*, can only be present in our consciousness as an awareness of the ultimately real—that is, as our recognition of the ongoing self-renewal of the cosmos in all its aspects. Being awake and in contact with the ultimately real requires each individual to undo the decentering distractions of personal and social history through a constant return to present time, and through the joining of every second to primary beginning. This is simply a definition of the creative act.

It is the professional responsibility of the artist to daily encounter the "Vast." One definition of the Vast is that it is something that exists beyond the boundary of personal memory. It makes no difference whether the content of this vast realm is explained as the entire evolutionary spectrum encapsulated within the genetic configuration of a particular individual or as a primary encounter with the supernatural embodiment of the essential archetypes.

The significant act of encountering the Vast is the realization of an immensity which no words can possibly describe. This immensity must destroy, in its great love,

the grand illusions of the individual ego. For the artist/painter, such an experience may result in a desire to participate more fully in the spiritual immediacy of life, even to the point of creating one's own Vision. The artist knows that while social history is built on temporal ephemora, the contents of the archaic are embedded in a self-renewing cosmic experience that transcends time.

The blueprint of the archaic is not merely ancient then, but rather an eternal beginning, which makes itself available whenever the barriers of history and materiality have been broken through. The creative act provides the conditions for living one's life within an eternal beginning that is impersonal, universal, and all-encompassing.

It is important for painters who love painting not to paint every day. The cultivation of a cosmic sense of being precedes in importance any expression of it. The creative act holds the promise of an inner quality of being as much as it is also an external expression of it. Wrapped within the sacred dimension, the creative act distills the peace and joy of a beginning that is eternally now. The blank canvas, then, is a vital instrument of rebirth into the sacred dimension. In the blank canvas the beginning is the end and in the end is the beginning. Throughout all of creation this is the pattern which connects. Acted upon, the oil painting arrives at spiritual power through the transubstantiation of its materiality. Transubstantiation is achieved through the laws of

internal necessity. Indigenous peoples of the world are able to speak to rocks and listen to voices issuing from mountain tops simply because they perceive the transubstantiation of materiality. Locked in its dream of history, Western civilization relies on intellect, logic, and greed, while dealing with a world of mostly inert but exploitable matter, of which nobody is a part. With the triumph of technology and intellectual materialism, the delicate original psycho-physical balance of human consciousness has been destroyed and a great rift has taken place between the body and the mind, the self and the world. Within the creative act, however, reconciliation is achieved through the abolition of history and the recovery of the joy, peace, and harmony of the sacred dimension.

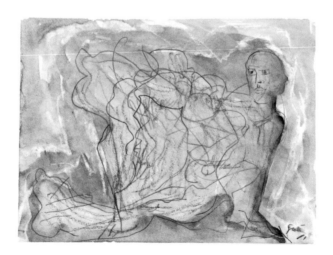

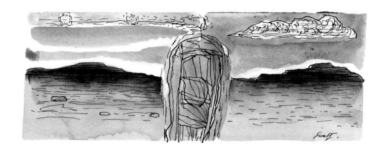

RADICAL ASTONISHMENT

A profound aesthetic experience is similar to what people call "religious experience." In both of these experiences, there is *ekstasis*, a kind of jolt or displacement, a sense of being beside oneself in a kind of exalted awareness, which in our contemporary vocabulary is ecstasy. Knocked out of the rut of distraction, one senses a cessation of linear time—quite literally, a "stopping of the world." Painters have come to understand that encounters with beauty are privileged moments in which one senses and engages the natural potential of human consciousness.

To put it another way, these are encounters with the Sublime. The Sublime is ultimate reality. The most intensely real thing, that thing with the utmost reality in this messy, hurly-burly and tragic world, is the Sublime. What we call "mystical experience," then, is nothing more than an encounter with that which actually is.

Deep in our hearts we all know that we desperately need a sense of the Sublime as much as we need food and water. If we were to take the time to prioritize our values, we would promptly realize that the experience of the Sublime is the one thing, next to love, which matters most in our lives. Tragically, this is difficult to recognize in our present culture, in which we are daily imprisoned by our own parochial conceptions, by our addictions and our fixations.

We live now in a fully rationalized world: if we can conceptualize and categorize it, if we can measure it, we assume we can control it. Locked inside this dynamic of acquisition and dominance, we are given to the sheer exploitation of the earth, and also, tragically, to the exploitation of one another.

It is our own insular conceptions and illusions which lead us to believe that we can measure everything and therefore control everything. We use one another in much the same way, always attempting to control one another in a manner that serves mainly our own self-interest.

To disentangle ourselves, to "stand aside," from the priorities of self-interest and exploitation, we must all realize how important it is to be released from the desire for control and coercion in our lives. Instead, let us choose to give ourselves over, and daily submit to the experience of Radical Astonishment.

We as human beings need to be perpetually astonished. Art, and its attendant experience of the

Sublime, feeds this potential for Radical Astonishment. But wonder and astonishment are not just part of an encounter with a great painting. Astonishment can occur in making dinner for friends, embracing a child, or watching the snow fall. To walk the path of art is one way of being in the world and sensing a grounding to the world. *Ekstasis*, then, is this sudden recognition of the Sublime in the midst of dailiness. It is the revelation of that indivisible unity which underlies and enfolds everything: that which has not been spoken, is necessarily silent, falls into silence, is the unspeakable.

What I am calling the unspeakable is what the theologian Paul Tillich refers to as "The Fundamental Ground of Being." We can permit our lives to be seized and overwhelmed by the Sublime. The Sublime is characterized by wonder. When we experience contact with the Sublime the only response possible is wonder. The Sublime grounds us in a naked, ultimate reality, which is our grounding in the world itself, a world fully revealed. *Ekstasis*, erupting in the midst of our ordinary human activities, drenched in its sheer beauty, throws open the doors of the sacred.

.

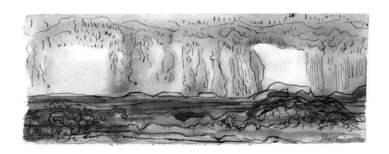

MOUNTAINS, STREAMS, VALLEYS, RIVERS, DELTAS, OCEANS: THE TRUTH OF PAINTING

Witnessing the light of early September, I see with utmost clarity the voyage of my life as a painter: from child to young man, to middle aged man, to a man in the youth of old age. I can see clearly that my voyage began in the snow melt of the high mountains. That snow melted into tiny meadow brooks and streams that drew and traveled over coarse, clean sand under the oaks and sycamores to, first the deep, then the wide canyons. Here these various streams emptied into various rivers. I remember when the various rivers emptied into the one great river and how, inexorably, my tiny white sail filled and I was guided through the maze of the depths to where I am now. Alone with my art: on the great blue breast of the ocean, I look to the far horizon where a bruised, white cloud lifts slowly from the darkness of the sea.

LIVING LIFE AS A WORK OF ART

An Interview with *THE* magazine, July, 2005

Whether Sam Scott's paintings are about the seasons, the clouds, a desert storm, or the human spirit, his palette and compositions bring the viewer face to face with the artist's interior spaces. Scott—a practicing Buddhist—met with *THE* magazine to discuss his artistic and spiritual vision.

PAINTING AS A BUDDHIST PRACTICE

It was St. Catherine of Sienna who said, "All the way to Heaven is heaven." I like to walk my old red dog in the melting snow of early spring. The snow melts, and it

melts into itself. The snow melts and sinks into the fresh earth, and then the little wildflowers follow and the tender green grasses. I want to be like that melting snow, washing myself of myself. Painting gives me a way to empty myself of myself, so that I also can melt.

LIVING LIFE AS A WORK OF ART

From the beginning, one's own nature is pure. If only I could be firmer, quieter, simpler, and warmer. To have truly been marginalized as an artist in a debased society —not as the avant-garde artist seeking attention, but as an outsider, an outlaw, as a bum, as a bum living on the waterfront with the other bums and with the rats. Not glamorous, but a total failure. That was useful. This is where I came to understand great faith, great doubt, and great determination. This happened, so that later the huge snowflakes might visit, falling in silence, no wind—just the pure ticking silence of the night. And now, getting old, I am frequently very happy. Painting is touch, and life is to touch, to love and to witness in the now. Beauty and tragedy are everywhere—the raven's breath in the freezing air, the old woman reaching for a bottle of aspirin. To live and to paint is to cultivate transparency. Art cannot be a substitute for life, but art can instruct us on how to live. Renoir said it is good to be a cork in the stream. Rilke said that it is good to let life

live you, as it is always right. And Ed Abbey had a toast
for his friends: "May your trails be crooked, winding,
lonesome, dangerous, leading to the most amazing view.
May your mountains rise into and above the clouds."

SHAPING THE UNBOUNDED

After a couple of drinks, Willem de Kooning loved to say,
"In da beginning was da void." It is said in Genesis, that
in the beginning was the void, and God acted upon it. For
an artist that is clear enough. And it is also so mysteri-
ous that it takes away all the doubt—one is utterly lost
in space forever. In other words, to paint is to accept
groundlessness as the proper place to be, always falling,
always going from the known to the unknown. We shape
the unbounded when we embrace emerging experience.
The painter participates in discovery when properly lost,
lost for a lifetime.

AWARENESS, ATTENTION AND BARE ATTENTION

Living in triple canopy jungle, one learns to survive by
not focusing the eyes when examining foliage to the side,
and instead learns to scan the farthest part of the trail,
which is right in front of you. When I was a young
painter, I stalked the painting. Now it is much better to
wait with patience and discipline until the news arrives.

Attention and awareness are the tools the painter uses in order to be beautifully broken. Bare attention is another way of speaking about how important it is for the painter to get out of the way. When we get out of the way, when we relinquish our desire to acquire, to possess, then we free ourselves from the tyranny of expectation, and we can create that kind of spaciousness, which will transport us to that waiting field of pure potentiality. Bare attention is unfocused and absolutely directed. It is in the zone of bare attention, where we may be free enough, to be able to follow orders.

THE ART I SEEK

Our poetry now might be the realization that we possess nothing. When we see that there is nothing to acquire and that there is no safety anywhere, acquiring nothing becomes a delight, and since we do not possess it, we do not need to fear its loss. I am not free from materialism. I love making art. I am trapped in paradox, with my brush, which is my mystery. I am not interested in reductive abstraction. I am not interested in decorative abstraction. I want an impure art, one that is raw and flawed, physical, brave, and full.

COMING TO ART:
AESTHETIC EXPERIENCE
AS A GROUNDING IN THE WORLD

History is the dream of reason. As long as humankind
believes in this dream and believes in the acquisition of
some sort of progressive historical identity, we will trag-
ically remain unconscious of the fact that we as a species
are a bridge between the cosmic realms of heaven and
earth. Inside this dream, our hopes will always focus on
some sort of future utopia; some place that, in all reality,
if it is progressively realized, will more likely be a
Catatopia: a psycho-technical intensification of hell on
earth. Our only escape as souls from this fatal samsaric

circle is to awaken from the dream of history and to assume our place as a basic, cosmic, and fundamentally timeless consciousness. I believe we have all had intimations, from time to time, that each moment is surrounded by eternity.

At the highest levels of endeavor, art is not a question of seeking. Picasso is said to have remarked, "I don't seek. I find." It is not the idea of artist as seeker, either, but rather the realization of the idea of the artist as artist. The artist as artist has come to presentness while living his/her art. A life lived in constant choice in present time deeply grounds the artist to the world.

"In prayer, come empty. Do nothing."
—St. John of the Cross

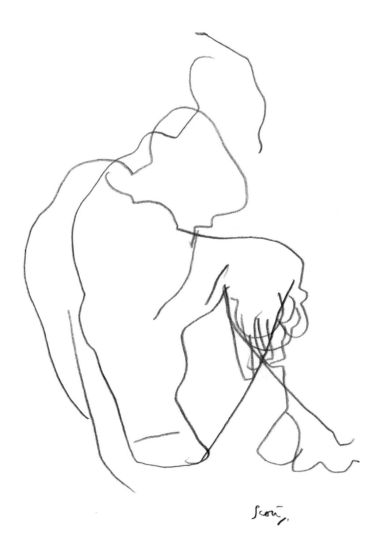

JACKSON POLLOCK:
SUICIDED BY SOCIETY

Remember that when Jackson Pollock first began to explore a range of hallucinatory dream imagery in 1939, James Joyce was just finishing *Finnegans Wake*. Both of these creators were working in that critical period when artists saw, out of their own internal necessity, an unavoidable reconsideration of traditional painting and traditional writing. By the end of that year, the world had erupted in a war that swallowed world civilization and arrived at a charnel ground. After Dachau and Hiroshima, illusions were shattered. Everything had to be cleaned away. How could one contend with *Deus Absconditus*, the God who hides himself?

Viewers would later constantly miss the point about the work Pollock produced after these world events, namely that, what was left on the canvas was the evidence of an experience: a snakeskin, a cicada shell. The painting was an evidence of Significant Experience: a souvenir of that experience. For Pollock, the moment of creation came in that moment of time when the thin, living wire of Duco enamel left the end of his stick, was airborne, and released in a dynamic interrelationship of control and surrender. In this way it was a moment of suspended beginning that was also impersonal, a moment of disinterested joy, in Kant's sense of forgetting oneself. With this great gift to Western painting, Pollock earned the dubious distinction of being a pioneer of what Harold Rosenberg was to describe as, "the tradition of the new." The newness of his technique became a fetish and was taken up by the popular press, where he was quickly dubbed "Jack the Dripper."

Once his technique had been heralded as the latest thing, Pollock's work was then interpreted as a radical exercise in artistic style. After his death in a drunken car crash, his life became the food of myth. Earlier, Van Gogh was suicided by society. Pollock, in turn, was suicided by the same dodges and misunderstandings. Pollock said, "Painting is self-discovery. Every good painter paints what he is." Tragically, with the cannibalization of his work by society, the triumph of Pollock's own authentic self-discovery within the paradox of the

absolutely impersonal had ceased to have any spiritually authentic meaning. It was buried in a concept of style, which became a packaged commodity for easy consumption. He had been cannibalized by society. That precious mytho-poetic impulse in Pollock, that is to say, the impulse that identified with the First Nation sand painters of the west, died in the style-conscious and consumer-driven world of New York art galleries and cocktail parties. The heroic achievement of the artist's surrender into a pure disintegration of consciousness became cannibalized and elevated to high fashion. As in primitive cannibalistic cultures, society and the art world ate the heart of their enemy. They devoured what they feared.

To a great extent, Pollock was a victim of the Moloch of society's debilitated hunger for the spiritual, which devolved into a blatant and insatiable consumption of culture. In post-World War II America it had very quickly devoured the exquisite immigrant European culture, and that voracious attitude continues on to this day.

We have to remember that the heroic significance of Pollock's art was in the artist's act. Enormous effort and energy are necessary in the creation of one's own deeply authentic ritual. Each person honestly pursuing this path must go his or her own way. Tragedy begins when this very act is commercialized and made into a linguistic media package. It is at this moment that a mental perversion has occurred. This perversion, more than any other,

characterizes the cultural disintegration of the post-modern world.

The current fashionable view of art is characterized by entertainment and the cult of the new. This cult of the new obviously demands newness—constant newness—and also demands that art continually change in style. The widespread search for fashion and entertainment has now become a striving after such extravagant novelty that it can only be obtained by ironic distancing and emotional cynicism.

In the 18th century, aesthetics was invented to isolate art from other fields. In the 19th century, the main art movements were all motivated by a spirit of independence—mostly from the salon system and the bourgeois values and marketplace that were supported by it. In the 20th century, the central question in art was the search for purity in the essence of each artistic medium. In each case, the important thing was the setting aside of art, respecting its singular place. Unfortunately, the concept of artistic purity soon became synonymous with artistic novelty. Both novelty and the purification of artistic media imply progress and, there-fore, both help to perpetuate one of the fundamental myths of historical consciousness. Unfortunately for our culture, we have not yet discovered that when we strive for novelty, it is always an inherently destructive process. Why? Because the New may exist only in the position of opposing that which it must necessarily

displace. Such a process can only be exhausting. To deny, continually, the foundation of what has come before us, is like jumping off the ground and saying, "This time I shall not land." Jackson Pollock's heroic attempt to achieve artistic and spiritual immediacy became synonymous with artistic novelty in the popular mind, and it broke his heart.

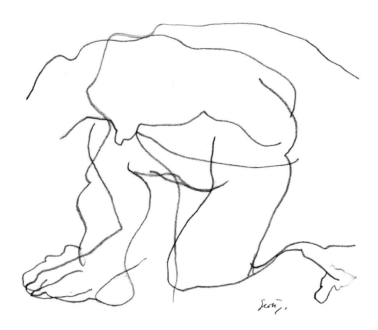

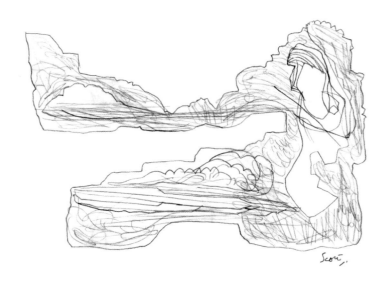

THE OUTCAST VISION:
VAN GOGH AND CHRIST

It is said that St. Francis of Assisi, during his meditations, was heard to say again and again, "My God, my God, what art Thou, and what am I?"

Paris in the 1880s was the capital of the world, an energy center through which the winds of the unconscious blew freely. Men and women from all over Europe and America congregated in the City of Light, where these cosmopolites formed a unique corps d'esprit. Ideas fermented and bubbled: lives acquired the potency of myth. For a brief, exalted moment the veil of materiality was penetrated, and in that penetration there was a

release of symbols, a tangle of visions of biological and social immediacy and utopian urgency.

Into this rich world came a Dutch exile from the stable provinces of reason, a one-time gospel preacher and art vendor, Vincent Van Gogh. Self-taught, self-willed, trapped in the brutal, competitive nets of a laissez-faire society, Van Gogh pursued his dream to its bitter consummation, only to be exploited posthumously by an adoring bourgeoisie that would have detested him had he lived next door.

More than any other figure, Vincent Van Gogh, described by Antonin Artaud as the "artist suicided by society," became the focus of our technological civilization's psychotic attitude toward creativity. In our modern society, creativity is associated with innovation and must be harnessed to the production of material power and the acquisition of wealth if it is to be respected. On the other hand, creativity that expresses fundamental truths, or confronts the life/death interface, or explores the intangible dimensions of feeling, dream, and intuition, is neglected, despised, and looked upon with suspicion.

The educational apparatus of the modern state discourages the development of creativity to such a degree that what is inherently spontaneous and normal in every child has atrophied in all but a few by the age of ten or twelve. From this select minority emerge the artists, who must then assume a creative responsibility, visually, in any case, for all members of society.

This situation was tolerable as long as the collective vision was clearly defined, as it was from the Renaissance well up until the mid-nineteenth century. But when the artists began to question it and the collective vision was no longer clearly defined, society at first became confused, and then finally turned away from the artists.

The artists, for their part, lacking society's support, turned their backs in defiance. For most avant-garde artists, this somewhat antisocial posture became the norm, accepted by both the artist and society, the result being that generally the artist was left to himself or herself while society, obsessed with its own materialism, rushed along in its own monomaniacally focused way. But from time to time there has appeared an artist who unconsciously draws forth the pent up creativity of the masses. For him or for her, life can become hell. Such was the fate of Van Gogh, who exemplifies the modern artist suicided by society.

Van Gogh's career as an artist lasted less than a decade. The subjects of his paintings came directly from the facts of his own experience: women bowed down by the bags of coal they carried on their backs, textile weavers, potato eaters, Paris street scenes, the fields of Southern France, the artist's chair, his bedroom, a field with a flock of crows flying above, and, most significant, the series of tormented self-portraits displaying Van Gogh's anguish, his narcissism, his paralyzing self-

doubt, his self-questioning. So driven and self-obsessed was this man that on being released from the hospital after he had cut off part of his left ear and sent it to a prostitute, he painted a self-portrait memorializing for all time this most telling and vulnerable act of his life. Yet this same self-portrait, depicting the artist in his most abject moment, hung for years on the wall of a steel entrepreneur's plush apartment, high above Lake Michigan in Chicago. The artist suicided by society: the artist digested and cannibalized by society. The farthest reaches of the artist's personal inquiry, cannibalized and digested by society. Seventy years later, Jackson Pollock met the same tragic fate.

I'm sure that it has crossed the minds of all of us from time to time, how ironic it is that Van Gogh's art, which earned him nothing while he was alive, should be so very popular after his death. At museum exhibits and art auctions, an adoring public pays homage to a man they never knew. That the personality and work of a single human being, who died threatened by insanity, lacking love and social acceptance, should be the object of so much fascination now, more than eighty years after his death, gives mute and pregnant testimony to the debased and vicarious channels creativity must resort to in our over-industrialized, materialistic, decentralized society.

The ironies of posthumous market value and blind collective adulation also reflect the misplaced guilt of

a society that does not realize the extent of its own historical decadence. If we all consider the actual values Van Gogh lived by, we must conclude that the only way for us in society to atone for his suicide is to individually accept the responsibility to be creative ourselves and to live our own lives with courage and heart.

"To sacrifice all personal desires, to realize great things, to obtain nobleness of mind, to surpass the vulgarity in which the existence of nearly all individuals is spent."[1] Quoting Renan, Van Gogh wrote this credo in a letter to his brother toward the end of 1874. At that time he was the frustrated employee of a prominent continental art dealer. In order to live out his ideal, Van Gogh subsequently gave up the world of business and entered the ministry. Failing at an effort to become an orthodox trained and ordained minister, he became an evangelist among the coal miners of the Borinage in Belgium.

Believing in the gospel of Christ, and living among the most wretched, debased workers of the Industrial Age, Van Gogh gave away everything he had in an effort to follow Christ's example. But to the exploited coal miners, this example of poverty was like a slap in the face. After a time, he was dismissed for "excessive zeal."

Van Gogh's deepest religious idealism, having been thwarted by the salt of the earth, turned at last to drawing and painting. He hoped to achieve through art what could not be achieved through living the gospel. His zeal

recalls Blake's pronouncement: "A poet, a painter, a musician, an architect; the man or woman who is not one of these is not a Christian."

Painting was the only form of worship left open to Van Gogh. The altar of his devotion was his own life. Furiously, he delved within himself for a means of expressing the living truth, for there was no one to teach him, and the spiritual tradition he might have turned to had long since lost its conviction for him. By sheer force of will, he slowly mastered the means necessary to convey his vision. But the energy mustered to achieve this goal was at the expense of all but the most basic survival needs: coffee and tobacco. In order to be creative, Van Gogh sacrificed all other personal desires. But he received no guidance or reward in return. After four emotionally abject, though artistically productive, years in Holland, from 1881 to 1885, he departed from his homeland for Paris, the City of Light. There his brother, Theo, introduced him to the new trends and the avant-garde artists, primarily the impressionists and neo-impressionists. As a result, Van Gogh's power of expression was augmented by the radiant use of primary colors. But the city was a jungle for the anxious and emotionally unstable artist. Too sensitive to the gross materialism of the urban environment and the keen competition it fostered, Van Gogh was seized by the Industrial Age fantasy of a return to the land. Coupled with his eccentric and indigenous mysticism was a long-

ing to go outside civilization, to escape the vulgarity of modern industrial society.

Van Gogh's departure from civilization in 1888 was as symbolic as it was real. If Adam and Eve had been cast from the Garden he would will himself back into it and into the bosom of the Lord. The idea behind his mystic flight was a kind of monastic impulse, to found a new society that would be fundamentally an "artists' colony" far from the taint of urbanization, where the pursuit of beauty would be sustained at a pace to match divine revelation. But the vision far outstripped the reality.

Art made a poor foundation for a community, especially since, in Van Gogh's case, it already served as a substitute for both God and lover. Van Gogh's art flowered in burning fields, sunflowers, cypresses, and starry nights, but banished from healthy human relations, the artist was to be sacrificed to the art. Artaud's epitaph for Van Gogh, "The artist suicided by society," is not quite right. Instead, we could say art suicided by society, the artist suicided by art.

Less than a year after his arrival in Arles, Van Gogh began to suffer from acute mental crises, including the infamous incident in which he cut off a slice of his ear. By the spring of 1889, the citizenry had requested that he be committed to a mental hospital. The next year or so, until his suicide in July, 1890, was spent in the asylum at St. Rémy, and, finally, under the care of a Dr.

Gachet in Auvers-sur-Oise.

The relationship with Dr. Gachet is interesting. It would seem that Gachet was far better suited to the career of a dilettante and art collector than to that of a physician. He seems to have been fascinated by the creative process but incapable of understanding it as pathology. (He was also a friend and collector of the work of another eccentric, Paul Cézanne.) Perhaps, like many of us today, he assumed that there is something inherently strange about artists. Perhaps he thought that they must suffer in order to be able to express so clearly what society can only feel so inarticulately. Such assumptions range far from the truth, for it is society's own unconscious and repressed creativity that is projected upon the tormented artist.

In the earlier part of this century, it was fashionable to try to diagnose Van Gogh's illness. Was it schizophrenia or paranoia, or tertiary syphilis complicated by epilepsy? The answer to the question would tell us very little, for fundamentally, Van Gogh's disease was not just a function of his own being, but rather a collective disorder focused through a single man. When a group of people abdicate their individual responsibility to be creative, a Vincent Van Gogh is necessary. His fate was inseparable from the industrial society of his time and ours.

Van Gogh wrote to his brother in July 1888 from Arles: "It certainly is a strange phenomenon when all the

artists, poets, musicians, and painters are unfortunate in material things; the happy ones as well. That brings up again the eternal question, is the whole of life visible to us, or isn't it, rather, that at this side of death we see one hemisphere only? For my own part, I declare I know nothing whatever about it. But to look at the stars always makes me dream, as simply as I dream over the black dots of a map representing towns and villages. Why, I ask myself, should the shining dots of the sky not be as accessible as the black dots on the map of France? If we take a train to get to Terascon or Rouen, we take death to reach a star."

Society's rejection of him enabled Van Gogh to penetrate beyond his misery to a unique insight, expressed as a living knowledge in his art. But his life remained a misery, and it is this discrepancy that gives such poignancy to his life story. While art is not a substitute for living life itself, it can show us how to live.

In August 1888, he wrote to his brother: "I always feel I am a traveler going somewhere and to some destination. If I tell myself that this somewhere and the destination do not exist, that seems to me very reasonable and likely enough. So, at the end of my course, I shall find my mistake. Be it so. I shall find then, that not only the arts, but everything else as well, were only dreams; that one's self was nothing at all. If we are as flimsy as that, so much the better for us, for then there is nothing against the unlimited possibility of future

existence. A child in the cradle has the infinite in its eyes. In short, I know nothing about it. But it is just the feeling of not knowing that makes the real life we are actually living now like a one-way journey on a train. You go fast, but cannot distinguish any nearby object. And above all, you do not see the engine."

Often, knowing little of these thoughts, present day crowds file past exhibits of Van Gogh's works in mute adoration, as if they were viewing the relics of a beloved religious master. The comparison is an apt one, for in a profound way Van Gogh is like a modern Christ. He took the burden of the collective creative responsibility on himself so that others might see in his art what was lacking in their own lives.

It is the tragedy of Christ that the masses have not taken up their own crosses and been reborn, but only worshipped at his cross. Likewise, rather than emulate Van Gogh's creativity and the authenticity of his feeling, the masses only worship what he produced. Not wanting to know him, we separate again, and place him on high in the altars of the museum, as if worship were atonement for ignorance and laziness. "I am the light of the world. He that followeth me shall not walk in darkness, but shall have the light of life." The failure of Christian civilization or any other has been its inability to live by the example of its teachers. This failure is the fall that has plunged us into the nightmare of history. That is to say, instead of living Christ's story ourselves, we have

others live it for us. Thus civilization must have its special personalities—the saints, the geniuses, the madmen. A reliance on them to seek ultimate reality is necessitated by our own abdication of vision and our forgoing of the creative powers of the spiritually regenerating forces by which the individual alone might become not merely an animal or a good citizen, but a fully conscious being.

Van Gogh realized this at the core of his being, and attempted to live the imitation of Christ as few others have. But the redemption he sought first for others and then for himself was beyond his grasp. In leaving civilization, he was attempting to leave this fallen history and live his-story—a life committed to attentive Being, taking the personal responsibility of attending to life itself in all its radiance. Although he made a copy of the Pieta of Delacroix and of the Lazarus of Rembrandt, by and large Van Gogh felt no need to paint Biblical subjects. At the instigation of Gauguin, he once painted the Agony of Christ in the Garden, but he later destroyed the work. His life painting in the olive groves outside the asylum of St. Rémy was the Agony in the Garden, and his Judas was history waiting for him to pull the trigger of the gun.

1. *The Letters of Vincent Van Gogh*, edited by Mark Roskill, New York, 1963, page 44.

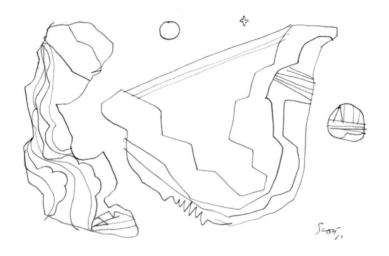

ON BEING FREE

Being free is not the same as having freedom. Being free is a quality of Being, whereas freedom is generally perceived as a possession to acquire.

The word "freedom" most often is defined in language by the preposition attached to it: freedom to choose, freedom to be, freedom to act, freedom of speech, freedom of religious thought, freedom of political view, freedom from hunger, freedom from fear, freedom from oppression. Freedom, thus described, is a definitive state. It is a noun that can be used as subject or object.

Being free is neither subject nor object: it is a verb, a vitalized condition of existence. Being free generates feelings of curiosity, and reawakens imagination to the

quiet possibilities of wonder and awe. In this condition, we all ask our own unanswerable questions. Through this process of questioning, with grace, we might come to perceive, reflected within us, that quality of the world which exists beyond mind and sight.

The yellow swallowtails are out in Pilar. I have just seen them riding the thermals along the banks of the river. One cannot help but admire both their tremendous strength and fragility, which are both aspects of the life force. Fragility lies with the individual and strength with the swarm. Yet the maintenance of the swarm is borne by the individual. This is the essential perpetuation of life, which is to say, all things. I believe this is why human beings regard the butterfly as the symbol of perfect freedom and take it as an image of the soul. I think of Papillon, the prisoner in a penal colony who chose the butterfly as his personal totem, tattooing the image on his chest and adopting its name.

In being free, we integrate the wonder of a child and the experience of an adult. We greet each day as though it was our last day on earth and, at the same time, as though we had all eternity.

A luminous network exists between all things. Being free is opening oneself to that network and participating in that luminosity.

Being free is allowing this inner structure of feeling to underlie all experience, unencumbered by preconceptions regarding either oneself or the experience. This is

existence understood mutually and non-verbally. A lemon, a cloud, a crow, a friend are visualizations of this truth. One wants to be traversing on that rope bridge between the known and the unknown, where our authentic self can speak to us in a way that has us deliciously surprised.

The hawk rides the summer thermals in an ascending spiral in the sky. With each climbing turn, the same point in space is touched, as if a plumb line were dropped that gives the comfort of perpetual return in constant ascension. As beings living free, we must revisit constantly the deep well of perpetuity. We must attempt to live vitally the imagination of regeneration and vision. One image of a truly un-free person might be, for example, that of a human being who can no longer say, "This is the land I have loved." "This is the family I have nurtured." "This is the bench that I have made." "This is my feeling." "This is the place I have created for myself in space and time." In our search for Beauty, we are constantly searching for a deeper vulnerability, a deeper fragility, an acceptance of our wound that can release us to our pure potentiality of living free.

WITH REVERENT FEAR
AND HELPLESS LOVE

"Let the beauty we love be what we do." Rumi

Although each move is ahead of the next, we know that there is still another way up, another way out. The essential message of art is that, although we as sentient beings essentially live in ignorance and pain, a great and healing knowledge beyond knowledge does exist. We sleep and could awaken. We experience ourselves in our trapped ego-body prisons as isolated, but could discover that we are, all of us, participants in a large and grandly meaningful whole. This great whole swarms as I experience it, but then often differentiates into exquisite auras,

embracing every creature and spirit that I see. It is
a trembling, vibrating, embracing whole, which is con-
stantly manifesting many from the One, just as waves
rise from the ocean then fall back to their original iden-
tity. Experiencing this primal whole, I am gently told by
that voice that has no sound, that suffering and death are
included and eventually transcended within the greater
whole, which preserves us, and however impersonally
tender, wishes us well.

We can only mold the clay of our spirit with reverent
fear and helpless love. And this message aids us. We
searchers, seeking identity in some deep sources of the
self, may look about and beyond to discover that the void
is absolutely charged with spirit—the Great Spirit,
which promises us the possibility of the plenitude of
a life fulfilled because it has been lived in wider and
deeper terms, and with profound sincerity, while we seek
Grand Frameworks.

THE MYSTIC AS CREATIVE ARTIST

A speech by Sam Scott
delivered at the United Nations,
New York City, New York, 1995

The Sufi mystic Al-Arvi speaks of the arc of human experience as a dialectic moving from non-being to being, and from being to hard work. He goes on to say that from non-being to being is the hard part, and from being to hard work is a natural organic step; hard work is like leaves falling from a tree, a natural process.

I have observed that people believe mystical experience to be some kind of visitation outside the fabric of everyday life; otherworldly, in other words, but this is not the case. What we are dealing with here is a matter of perception. "The mystical" exists in each of us at all times. However, we deny ourselves perception of it.

Today, I will attempt to demonstrate that what we call mystical experience is actually our Union with Fundamental Reality. This is to say that what we call mystical is the experiencing of that Union. And, a mystic is a person who has either attained that union in a greater or lesser degree, or who believes in and aspires to the possibility of such attainment.

Let's discuss "Union" for a moment. Remember, knowledge is only accomplished by the union, assimilation, and mutual penetration of a thing with ourselves. In other words, we know a thing by the process of uniting with it. "It" gives itself to us, just in so far as we give ourselves to it. In our relationship to the fundamental ground of being, to creator, we must be in an intensity of union, which the nineteenth-century mystic and theologian Pierre Teilhard de Chardin describes as "the cosmic covenant." It is because in the press of daily life, our outflow towards things is usually so perfunctory and so languid, that our comprehension of things is perfunctory and languid as well. How does the mystic as artist living in the world break through this habit of perfunctory inattention? By cultivating wonder. The job of the mystic/artist then, is to cultivate wonder.

Some Disciplines in Cultivating Wonder

1. Respond to all being as illusion. Rocks, trees, clouds, suffering, joy—all the phenomena of our alive-

ness we can understand as absolutely concrete and real, filled with delight and dread. But they are also, at the same time, illusory.

2. Catch the secret. At the heart of all being, there is a secret. We must detect this secret to treasure and to prize, to keep ourselves going on our journey to the end.

3. Move deliberately beyond doubt. Doubt leads to hope. Through faith, hope leads to certainty. But, darkness is where light shines. We must move beyond the conceptual prejudices to which we cling and move forward with reckless abandon, permitting what we know to be truth to possess us.

4. Be maladjusted to the empire, to those values which are spiritually insupportable. Ecstasy is procivitas. In order to prevent forgetfulness, engage in a creative subversion of the unreal world. Don't drift, don't float the cosmic covenant that no thing in this world can come between us and our creator. Open up and open out in sublimity, in wonder.

5. Meet all being with radical openness. Be wary of closed mindedness, fear, or suspicion of all values. Be open to the transcendent, be alive and awake to watch what's going on. Being radically open to being makes us transparent and keeps us from sodden self-involvement.

6. Take nothing for granted: something beautiful, something terrible, something normal. Drink it all in with your senses, in total attentiveness.

7. Marvel that you exist.

8. All being is unbelievable. Everything is miraculous.
9. All experience points to the sublime.
10. Allow yourself to be seized by the sublime. Let go of control. Overcome control. Become docile, enraptured, receptive. Spend time with children. Refuse to be "underwhelmed." The empire is "underwhelmed." Let the fact of our Fundamental Reality overwhelm us.

Let us devote ourselves now to a definition of "Fundamental Reality." Fundamental Reality is that exquisite spaciousness which is revealed when we permit our minds to transcend the concepts of opposites and duality: terms such as subject-object, rationalist-dreamer, intellect-intuition. The situation is simply this: on what, out of the swarming mass of material offered to us, shall we focus our attention—with what aspects of the Universe shall we "unite?" Because we are terrified by the idea of mystery, we tend to sequester our experiences in symbols and labels. We all know, however, that a great emotion, or some devastating visitation of beauty, love, or pain, can hurl us to another dimension. This dimension is what I am calling today, Fundamental Reality, the Experience of Wonder, or if you prefer, Absolute Sensation. Absolute Sensation is this majestic spaciousness: the inner spring and secret of our individual lives.

For the artist, Absolute Sensation lives in the impassioned contemplation of Pure Form, through this cultivation of wonder. The full impact of all manageable

beauty and wonder, freed from all the meanings with which the mind attempts disguise, is the direct sensation of life having communion with life.

The artist is a mystic when he or she passes beyond thought to a pure apprehension of truth, beyond conceptual image to intuitive contact with Fundamental Reality, rather than relying on reaction and rearrangement of experience. The artist as mystic destroys the illusions of multiplicity. The world of appearances buzzes like a swarm of bees, yet at the center is a stillness in which the rhythm of our mortal duration is one with the rhythm of immortal life. In this place, our essential self exists.

The artist, then, is no more and no less than a contemplative who has learned a language of expression which emphasizes that Reality inhabits and yet inconceivably exceeds us. In other words, union with Fundamental Reality is at once union with Change and also is union with the Whole. This is what the contemporary Carmelite theologian, Father William McNamara, calls "A Long, Loving Look at the Real."

Let's take "A Long, Loving Look at the Real." Look at the back of your hand. Trace the pattern of veins there, and think of the resemblance to the veins in a cabbage leaf, the delta of a river, the shape of a lightening bolt, a galaxy. So you see how these patterns that connect in form and scale ultimately give way and surrender to a way of understanding that is transpersonal? These patterns that connect are a clue, a sign to us of a

magnificent sensibility that is beyond our cognitive powers to understand. If we can yield to, if we can be loyal to this divine mystery, we will achieve union with Fundamental Reality.

This is the nature of mystical experience; this is what the artist seeks. It would be simple to say that the artist is mystic, seeks the universal in the singular, but the key is there. In painter's terms we simply must get out of the way.

The disparate identities that constitute our daily lives are phenomenological interpretations of mind and they are distortions of a pure, silent, and immeasurably shining place available to us all.

The title of this talk is The Mystic as Creative Artist. Both mystic and artist, however, are nothing more than emissaries, messengers who represent all societies and cultures of the world. Their singular discoveries are meant to be shared with our collective world humanity. The news that they bring back is the possibility of grace, a reconciliation of man to mankind at the dawn of this new millennium.

That which we call mystical experience is nothing more than the glorious miracle of sentient being, and the miracle of each day. As Camus says, "Each day is a God." If we can accept this miracle as part of our lives, we can enjoy a new definition of what it means to be truly human.

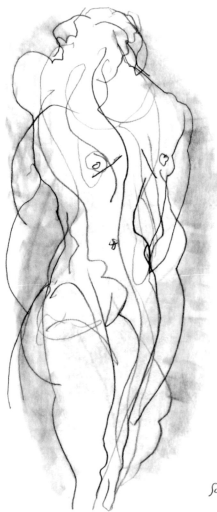

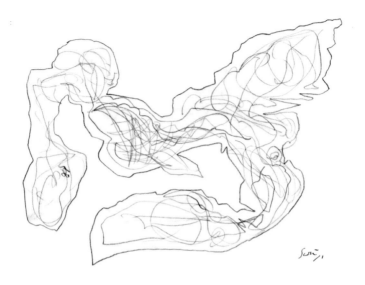

FREEDOM AND CHOICE
IN MORAL SPACE

One way to think of beauty is as evidence. For example, beauty in the work of art is a direct evidence of the inescapable fact that we cannot live successfully without experiencing qualitative discriminations of the incomparably higher. Sometimes one feels that these discriminations must refer to an absolute standard. The painter knows, however, that great truths inhabit paradox. While petty ideas may meet in linear opposition, great truths always embrace otherness.

An extremely valuable idea that has evolved out of the sanctity of studio life, the daily contact of studio life,

is the concept of the Grand Frameworks. The painter cannot do without Grand Frameworks. Grand Frameworks hold those strong qualitative discriminations that refer to an absolute condition, which, in turn, supplies the gift of an expanded horizon. This horizon offers qualities of clarity, spaciousness, and meaning that help us to discover our place and make sense of our lives. Grand Frameworks feed our hunger for the Real. The painter understands that we are humanly grafted to the universal by that which is most our own.

Art offers us this gift of location in moral space. Moral space frames the relationship of beauty to the flow of our lives. In dealing with the inescapable temporal structure of being in this world, we find that our lives must have a sense of direction, an awareness of where we have been in order to understand that which we shall become. This sense of observant passage towards what we are not yet is the artist's path and the work of art is the evidence of that quest.

On this journey towards that which we are not yet, we operate in a condition of constant choice within a state of continuous becoming. To live attentively with the unfolding of constant choice is to exist in a constant present, which is an attribute of freedom. Therefore the experience of presentness and the act of creation are intricately interrelated, for it is here that the painter, with luck, might encounter that *ekstasis* of precognitive experience which lies at the heart of the creative act and

sparks one particular kind of beauty. The job of the painter, in other words, is to be a connoisseur of experience. The job of the artist in this journey from the known to the unknown is to experience one's experience.

As painters, we also wish to experience freedom as a condition of spacious choice. This spatial metaphor is critical to human thought. The spatial metaphor of the multidimensional has always been critical to human thought, but contemporary culture emphasizes linear experience. Dominated by an idea of backward or forward, linear experience is not spacious, not multi-dimensional, but is instead driven by means and ends.

Consequently, in contemporary linear moral space, the experience of freedom within a decisive moment is fearfully rare. Because it is rare, it is extremely precious. A decisive moment in contemporary linear culture tends to be identified with moments of decision that are made in a cramped moral space and often accompanied by a sense of urgency. Tragically, the entire issue soon converges on the question of whether, under such circumstances of intense social pressure, moments of freedom in decision do indeed exist at all.

The artist, the painter, sets against this a radically different metaphor of physical and meaningful space. In this other space, the space of the painter, the space of the creator, there are no barriers to the free movement of thought and feeling. Everything is open, and responds like a cloud or a field of forces. One enters into variously

placed Grand Frameworks that are posited multi-
dimensionally. Exquisite particles fly in all directions;
they come together, collide, and shoot apart in no set
pattern. As this grand, chaotic whirl swells, other forces
or particles impinge upon it, engage it, perhaps trail
after it and then fall behind. This is the artist's journey
from the known to the unknown. The painter picks his
way, making choices in a star-field of volatile and
unstable forces. Most fundamentally, then, a choice is
not something rare that offers itself to us only after a long
wait. Artists know that choice happens constantly, at
every exquisite moment. In this constant choosing, the
painter encounters another form of great beauty in open-
ness. One is always in the center of the circle because
the circle is so large that the center is everywhere.

Possibility, choice, and the consequences of choice
happen constantly at every second. Every step and every
move the painter makes during the creation of a painting
could have been otherwise. This is very important. In
this space of infinite possibility, which the self experi-
ences through the magnificent arc of life, choice offers
itself in a richly various continuum. Spacious freedom
does not resolve into mere duality. There is never just a
simple fork, a definite either/or, but instead at every step
the path might move in countless directions. As Yogi
Berra says in his famous quote, "When you come to a
fork in the road, take it!" There is no narrow corridor of
choice, but rather an expanding atmosphere of not yet

realized possibility, which surrounds us, and at every second we may and might select one possibility from the swarm of others and give concretion to concept as we feed our hunger for the Real.

Freedom, therefore, does not at all signify the attainment of a goal, or the capacity to acquire, or any sense of grasping. On the contrary, freedom more nearly marks a level below which we cannot fall, a quality of lowest stratum that cannot be transgressed. This is the spacious floor, the spreading plain beneath our feet in moral space.

The artist knows that discipline gives birth to freedom. The artist also knows that merely having a choice does not make one free since everyone would be free if that was all that constituted freedom. "Free choices," if this means choices made in the absence of duress, do not exist. In the creative act, then, obstacles and risks do not make an act unfree, they only make it harder.

In the path of art, a sense of journey coexists with our condition of infinite choice in the continual present. Moral space is complex and multidimensional, because on the one hand there are choices to be made with will in present time, and on the other hand, we must continually examine our past, seeking to understand where we have been and to know whether we might move forward to see where we are going. The painter knows that the experience of making art is the experience of a field of

questions. The painter's questions begin with identity and proceed to place. For example, "Who am I?" moves to "Where am I?"

My dream, as a painter, having achieved some sense of orientation in moral space, is that I might, more and more, experience that actual presence of Ultimate Beauty, that presence which signifies that reality has, at last, finally, become Real, that moment when there is intimate contact with an infinite transcendence. Attempting always to stay in the field of gratitude, the path of art succors the Self. Our orientation in moral space is determined by keeping our covenants with the privilege of consciousness, and leads us to praise all our wonder before the pain and splendor of experience.

We need faith in the world. We need hope for the world. Faith and hope bring reconciliation of self with the universal, and we can return to where we came from in full reparation for the gift of life, knowing that we have been true to our inherited cosmic covenant, and that all is well.

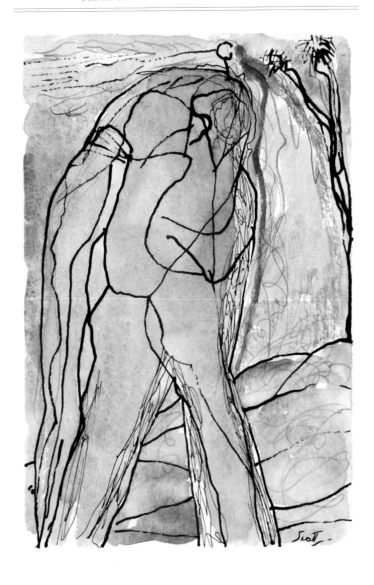

THE ARTIST'S PATH:
PROMISE AND FORGIVENESS

The human self who inhabits this world is redeemed from the predicament of meaninglessness by the exquisite gifts of significant action and significant speech.

If we consider the history of human consciousness, we realize that human souls are redeemed from imprisonment in the ever-recurring cycle of the life process through our voluntary and active participation in the consciousness of continuous choice. This continuous choice of significant action and speech always takes place in present time.

After all, our human affairs are governed by the law of mortality, which is the most certain, and the only reliable law of biological life spent between birth and death.

It is the faculty of significant speech and action, however, which intervenes with this law by interrupting the inexorable automatic course of the life process through the volition of choice and the initiating of processes with unpredictable consequences.

Expressed as one complete concept, then, constant choice in present time represents a kind of continuous responsibility to conscious awareness and conscientious action. We must search constantly for a particular kind of Action in Being whose result is the invocation of meaning through the articulation of thought. This particular kind of Action in Being, is the grand gift and function of Art.

We find a fuller sense of life then, through our articulation of it. We mortals have become acutely aware that just how much significance our condition of *being here* in the world holds for us, depends on this very articulation and the cultivation of our own powers of expression. In other words, finding a sense to our lives depends on the framing of those meaningful expressions which are adequate to our human person-hood, through those very acts of invention and articulation which invite meaning.

Among these very particular sorts of privileged inventions and articulations is the activity of Art. Art protects society from nausea and meaninglessness. This is the invaluable gift which the artist may offer society. Without Art, the world loses access to one of the chief

miracle and potential of our original birth into the world.

Promise and forgiveness belong together, and coexist together as indispensable Grand Frameworks, grand constellations which guide our artist's path through life, expanding moral space in time. That is, forgiveness serves to undo deeds of the past, while promise offers islands of security in the chaotic ocean of the future.

Without the possibility of forgiveness and release from the consequences of what we have done, our capacity to act would seem as if it were confined to one single deed from which we might never recover. We would remain the victim of the consequences of that action forever, not unlike the sorcerer's apprentice who lacked the magic formula to break the spell of his mistake. If there were no possibility for the consequences of those missteps to be met with forgiveness, it would be impossible to move forward. Forgiveness offers reversibility, and establishes the space in which promise may be renewed, and reborn, and newly adhered to with all our strength.

Without being bound to the joyous responsibility of fulfillment of our promises, we should never be able to keep our fluid identities, for the loss of that Grand Framework would condemn us to wander helplessly and without direction in the darkness of each human being's lonely heart.

Nietzsche, in his extraordinary sensitivity to moral phenomena, called this faculty of promise and its

It is the faculty of significant speech and action, however, which intervenes with this law by interrupting the inexorable automatic course of the life process through the volition of choice and the initiating of processes with unpredictable consequences.

Expressed as one complete concept, then, constant choice in present time represents a kind of continuous responsibility to conscious awareness and conscientious action. We must search constantly for a particular kind of Action in Being whose result is the invocation of meaning through the articulation of thought. This particular kind of Action in Being, is the grand gift and function of Art.

We find a fuller sense of life then, through our articulation of it. We mortals have become acutely aware that just how much significance our condition of *being here* in the world holds for us, depends on this very articulation and the cultivation of our own powers of expression. In other words, finding a sense to our lives depends on the framing of those meaningful expressions which are adequate to our human person-hood, through those very acts of invention and articulation which invite meaning.

Among these very particular sorts of privileged inventions and articulations is the activity of Art. Art protects society from nausea and meaninglessness. This is the invaluable gift which the artist may offer society. Without Art, the world loses access to one of the chief

avenues of aspiration to a higher self, that higher angelic self spoken of by Blake and Ginsberg, the spiritual self that converses with the incomparably higher. What an unhappy condition it would be if we were subject only to the necessity of labor and consumption as the overriding value in our lives. A world solely determined by a category of means and ends risks the devaluation of all values, making it impossible to find valid standards. Imagine a world without Mozart or Coltrane, without Fra Angelico or Rothko or Cezanne or Neruda. Living in such a world would be like viewing the sky without birds.

Our world, which circumferences the privilege and suffering that attend our physical habitation of it, is sustained by our human capacity for labor and fabrication. The redemption of human life, however, may be found in the activity of Art, which is the mobilization of another absolutely necessary human capacity that produces meaningful and useless images, activities and stories as naturally as fabrication produces use objects. The artist's path then, is to facilitate society in the framing of those meaningful expressions of Reunion with the Incomparably Higher which are adequate to meet our deepest human needs, so that we as a civilization might encounter the ultimately real.

However, there are great risks associated with such significant actions, for the artist as well as others. Through action the artist releases those possibilities of

irreversible and unpredictable consequences which are ignited by the process of acting.

One remedy for unpredictability and the chaotic uncertainty of our future lies in the faculty to make, and to keep, promises. At the same time, however, it is extremely important for us to know that another possible redemption from the predicament of irreversibility lies in our faculty for forgiveness.

Promise and forgiveness are the two grand dynamics of the creative life. As artists, we assume an enormous responsibility, making a promise to ourselves and to others to perform significant actions in a variety of ways. Because of our fallibility, our human frailty, we shall from time to time fail to perform these actions correctly.

Action, through its capacity to intervene and initiate new processes or directions, is the one miracle-working faculty of men and women. The power to forgive, however, is on the same level, and always within reach of human potential. If we as a species could fully follow this potential, our beautiful planet earth would be inhabited by loving civilizations. With John Lennon, we must imagine.

Being human, we fail. Yet in our power to forgive, we hold in our hands the miracle that saves the world: for the enormous fact is that forgiveness offers us in its awesome essence, *natality*. In other words, with forgiveness, we offer each other the possibility of a new beginning, starting over, a rebirth that redeems and reopens the

miracle and potential of our original birth into the world.

Promise and forgiveness belong together, and coexist together as indispensable Grand Frameworks, grand constellations which guide our artist's path through life, expanding moral space in time. That is, forgiveness serves to undo deeds of the past, while promise offers islands of security in the chaotic ocean of the future.

Without the possibility of forgiveness and release from the consequences of what we have done, our capacity to act would seem as if it were confined to one single deed from which we might never recover. We would remain the victim of the consequences of that action forever, not unlike the sorcerer's apprentice who lacked the magic formula to break the spell of his mistake. If there were no possibility for the consequences of those missteps to be met with forgiveness, it would be impossible to move forward. Forgiveness offers reversibility, and establishes the space in which promise may be renewed, and reborn, and newly adhered to with all our strength.

Without being bound to the joyous responsibility of fulfillment of our promises, we should never be able to keep our fluid identities, for the loss of that Grand Framework would condemn us to wander helplessly and without direction in the darkness of each human being's lonely heart.

Nietzsche, in his extraordinary sensitivity to moral phenomena, called this faculty of promise and its

importance to human identity the "memory of the will."

Memory of the will extends also to forgiveness. The artist's path must engender a cheerful good will to counter the enormous risks involved in action by valuing a readiness to forgive and to be forgiven, just as it also strives to fulfill the commitments of its essential promise. Without the balance of these two covenants, we would be doomed to swing forever in the ever-recurring cycles of a world without meaning.

Death is waiting for us. There is nothing we can do about it. Life and consciousness stand against the awesome power of death as sacred incantation and miracle. Life itself is a miracle. In statistical terms, given the proportions of the universe, life is an infinite improbability, and yet it occurs regularly on earth. While the significant actions of men and women interrupt the fatality of our mortal life span by initiating new processes with unpredictable outcomes, the power to forgive those mistakes which arise out of action and our human frailty is an act of faith that permits hope and the possibility of grace.

Against mortal fatality, it is faith and hope, those two absolutely essential components of human existence, which offer natality through the marriage of promise and forgiveness.

The courage to love and forgive provides us with promise in the face of our infinite potential for both success and failure, and gives us permission to be born.

ACKNOWLEDGMENTS

I would like to thank Ruth Lathrop, my office angel, for her encouraging me to gather together all of my yellowing scraps of paper and composition books, and her skill and patience as we assembled the first rough draft of the manuscript. I would like also to thank my friends Kay Fowler and Nancy Stem of Fresco Fine Art Publications for their profound support and belief in this project. I would also like to give a big "Thank You" to Bill Peterson, publisher, critic, and my friend of thirty years for editing and introducing the contents of this book. He curried and tamed many a wild and out of control thought or sentence, groomed it and made it behave.

Finally, I would like to say thank you to my wife Leslie McNamara for her courage, delight and wonder in life. She has taught me the real meaning of beauty.

Sam Scott
Santa Fe
February 19, 2007

LIST OF WORKS

SAM SCOTT

WATERCOLORS
2004–2007

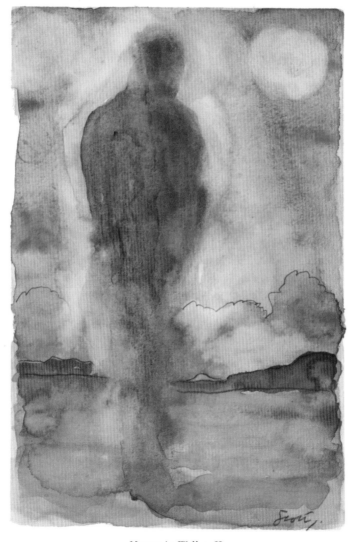

Mountain Walker II

Walking Man

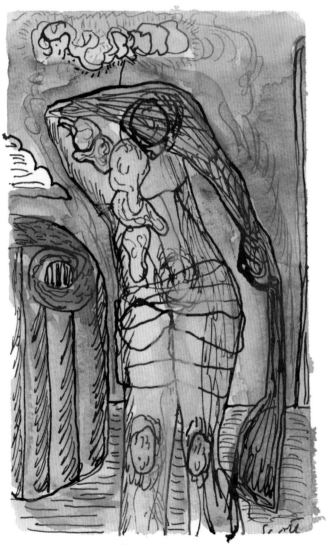

Planting the Oar

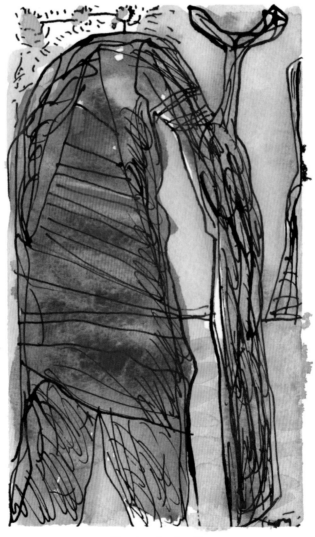

Planting the Oar II

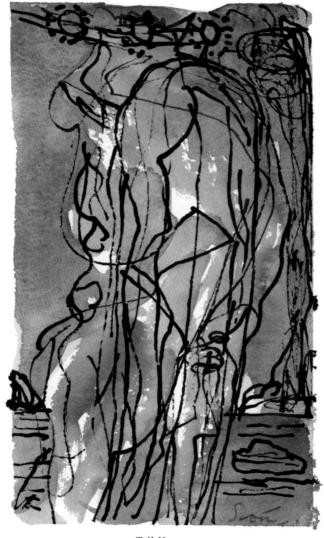

Tall Horse

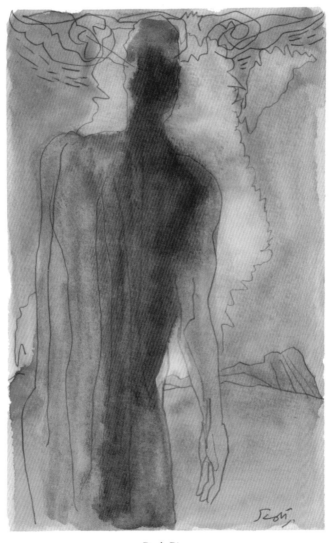

Dark Pine

Dark Pine II

Peace Prayer in Flowering Yucca

Cloud Man

Walking Man III

Walking Man IV

Kneeling Man

Walking Man II

Peace Prayer

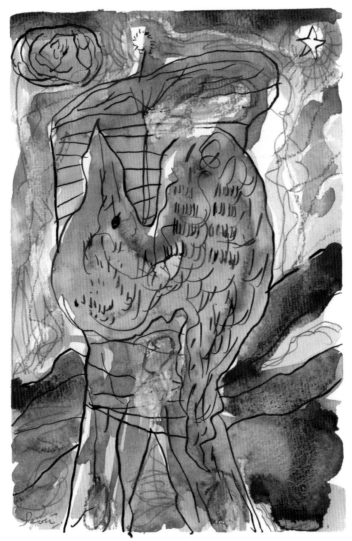

Peace Prayer with Morning Star

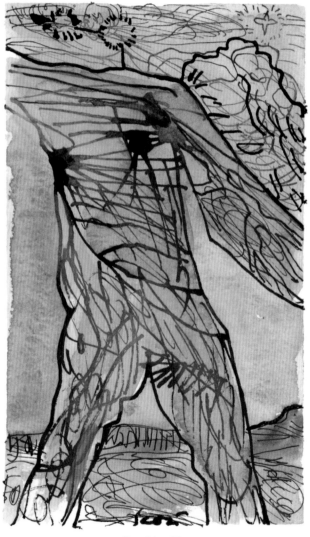

Reaching Man

Walking in Lightening

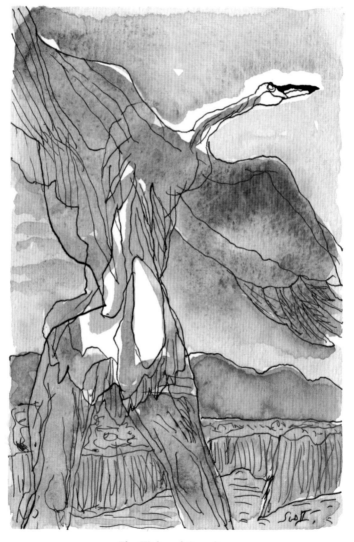

The Widowed Canadian

Yellow Horse Walking

Mountain Oak Walking

Song of the Canyon Wren

Walking Rain

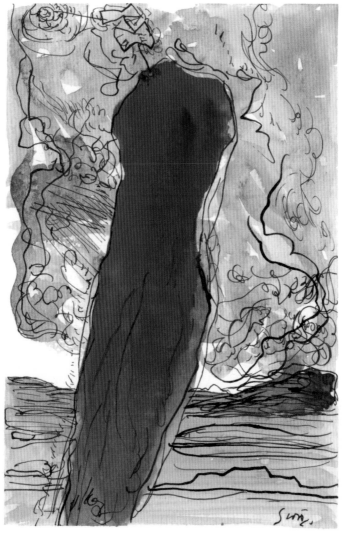

Standing Mountain

William Peterson is an art historian, critic, and editor. From the mid-1970s to the early 1990s he was the editor and publisher of *Artspace* magazine, a critical journal of contemporary art published in Albuquerque and later Los Angeles. He has been Associate Editor of Museum Publications at the J. Paul Getty Museum in Los Angeles, a frequent correspondent to *ARTnews* magazine and other journals, and his critical essays have appeared in numerous museum and gallery exhibition catalogues. He also contributed an extended critical survey of Sam Scott's work to *Sam Scott: Drawings, Watercolors, Oil Paintings*, published by Fresco Fine Art Publications in 2003.

Sam Scott lived with the Oglala Sioux people in 1958. He lived with the Makaritari people in the Amazon Rainforest in 1968–1969. He enjoys painting wild spaces.

Since 1969 Scott has made Santa Fe his home. He lives with his wife, Leslie, and cat, Cooter, and loves to walk to his studio every day.